NORTH LIGHT
ARTIST'S WORKBOOKS

Calligraphy Techniques:
Upper Case Italic

WORKBOOK 2

Karen McMannon

NORTH
LIGHT
BOOKS

Cincinnati, Ohio

ACKNOWLEDGMENTS

My sincere appreciation to:

my Editor, Diana Martin,
for her delightful technique
of squeezing ink out of a new author;

my Aunt Ann,
who "never got" a lesson;

my students,
who teach me;

my fellow calligraphers,
who continually share their skills
and enthusiasm;

my parents,
for their unfailing faith;

my children,
for not eating the daisies;

my husband,
for love.

Calligraphy Techniques: Upper Case Italic. Copyright ©1987 by Karen McMannon. Printed and bound in Hong Kong. All rights reserved. No part of this book may be reproduced in any form or by any electronic or mechanical means including information storage and retrieval systems without permission in writing from the publisher, except by a reviewer, who may quote brief passages in a review. Published by North Light Books, an imprint of F&W Publications, Inc., 1507 Dana Avenue, Cincinnati, Ohio 45207. First edition.

ISBN 0-89134-198-6

Edited by Diana Martin.
Designed by Clare Finney.

Introduction

Improved within the past twenty years but hardly new, the upper case letters of the five-century-old Italic hand have more precision and beauty today than ever before. The Italic upper case, or *majuscule,* letters were formulated from the Roman Capitals, right, which visually proclaimed the power and the strength of a once mighty empire. As time evolved these letters became *swashed,* or *oval* and slanted to better suit the continuity of the lower case, *minuscule,* Italic letters, which you learned in Workbook 1. (If you haven't completed Workbook 1, I strongly urge you to do so before going on with this one. To achieve your fullest potential in calligraphy, you need to be skilled in both the lower and upper case letterforms.)

The capitals can be written in many shapes and flourishes, some of which will be introduced in Workbook 4, Formal Italic. For now, however, you'll be learning a more basic style, shown at right. I chose these particular capitals because, although lettered on the same writing slant as the lower case alphabet, they are like the original Roman style, strong and distinct. Their development is largely due to the study and talent of contemporary calligraphers. I personally appreciate what Fred Eagers, Jacqueline Svaren, and Sheila Waters have taught me.

This is the second of the *Calligraphy Techniques* workbooks, a series that will guide you in teaching yourself the Italic hand. This and subsequent workbooks utilize the trace and copy method of learning. The shaded letters are the ones you'll trace. As you trace the first few letters, your fingers will get a "muscle memory" of the correct formation, and this will make it easier to do the movements on your

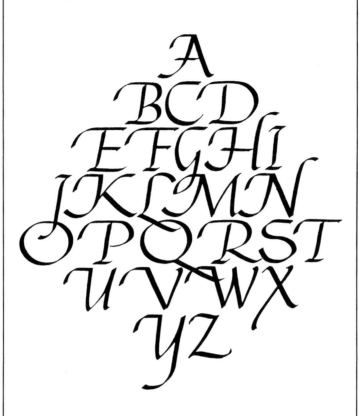

own. After you've traced letters, you'll copy them on your own.

THE PROJECTS
In this workbook you'll learn how to write upper case let-ters, numbers, and punctuation, and then combine them with the lower case letters so you can use calligraphy more fully. As in Workbook 1, you'll immediately put your

pen into motion by tracing and copying specially designed projects.

In Project 1 you'll reacquaint yourself with the proper penhold and 45-degree nib angle, elements that are critical to lettering upper case letters. Project 2 introduces the basic elements, such as the horizontal pull stroke and side serif, which make up these letters. It then teaches you the actual upper case letters. In Project 3 you'll practice letter spacing, which is especially important when combining an upper case letter with lower case letters.

Following Project 3 is a unique Troubleshooting Chart which will help you identify and correct any weak letterforms. In Project 4 you'll learn numbers and punctuation; in Project 5 you'll combine these with your upper and lower case letter skills. Finally, Project 6 shows you how to pull all your calligraphic skills together to letter lovely monograms for use on any type of correspondence.

Once you've completed all the projects in this workbook and feel comfortable writing the upper case letters, move on to Workbook 3, where you'll learn cursive Italic, and then to Workbook 4, which covers formal Italic.

PEN AND PAPER
Use Speedball's Elegant Writer pen, in nib sizes *broad* and *medium,* shown left, as you did in Workbook 1. (Don't confuse this with the Speedball Classic Elegant Writer; its permanent ink will bleed, enlarging your letters.) Other brands of pens in comparable nib sizes may also be used for these exercises, but be sure to test the width of the pen against the letter stroke to be traced before you begin. Your pen nib should fit exactly onto the letterform.

Each exercise clearly indi-

■ Here you can see the variation in letter size between the medium and broad nibs.

cates which size nib—*broad* or *medium*—to use for the line spacing. After you feel comfortable with your letterforms you'll progress to the fountain pen and the dip pen in Workbooks 3 and 4.

You can letter on any paper surface, but the effects will vary depending on the paper texture and absorbency. The smooth surface of the practice sheets in this workbook allows an even ink flow. The diagonal lines will help you establish a comfortable slant for the Italic style. Once you've completed the worksheets, continue practicing on a pre-lined calligraphy pad, bond or typing paper (you can line it yourself or slip guidelines underneath), or even old newspapers, which are lined by the rows of type.

SITTING POSITION
Posture is extremely important. It affects your energy and attitude. Most of us must continually remind ourselves to sit up straight, place both feet flat on the floor, rest the writing elbow upon the table top, hold the pen firmly but not tightly, use the non-writing arm to hold the paper (and not hold up the head!). I can generalize like

this because incorrect posture is predictable. Sometimes I feel like an hourglass because the sinking of my head toward my writing is in direct relation to the length of time I'm able to write.

Writer's cramp is an occupational hazard caused by repetitive movement. The areas affected by this stress are your fingers, hand, arm, shoulder, and back. The cure is to relax. You must first be aware of tension and then coax yourself to take time out to treat those muscles you've been using. You may want to shake out your hand or get up and move around. Specific calisthenics for cal-

ligraphers can be found in Workbook 3.

PRESENTING YOURSELF TO YOUR PRACTICE
It isn't the pen, ink, and paper that make calligraphy happen. It's you. Remember that in learning calligraphy, you are learning a skill, and every skill requires discipline and practice. The effort you put into mastering the Italic hand will be proportionately rewarding to you in your calligraphic results.

To experience satisfying practices be totally aware of what you're doing, relax, and enjoy doing it! When

you are distracted or physically tense, it's time to put the pen down. A project needn't be completed at one sitting. Don't rush through an exercise just to get it done; it's essential to apply utmost concentration to your task at hand. Take time and care and above all, be kind to yourself. Once the practice sheets are completed, save them and review them later to prove that your calligraphic skills *are* improving.

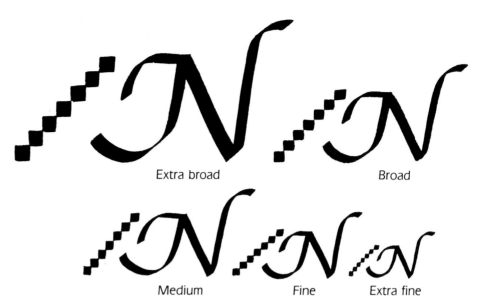

Extra broad Broad

Medium Fine Extra fine

■ Here you can see how the size of your nib affects the size of your upper case letters.

Karen McMannon

Project One

PENHOLD AND NIB ANGLE

PEN ANGLE

The Italic style is simple yet elegant. The thick and thin elements achieved by holding your pen nib at a 45-degree angle create that elegance. You worked at that angle when writing the lower case Italic and it should now feel quite comfortable.

PENHOLD

Your penhold should be light, yet firm, relaxed and comfortable. Grasp the pen with your thumb and forefinger and rest it on your middle finger. Tuck the remaining two fingers in toward your palm and lightly touch them to the writing surface. These two fingers will guide your hand movement. The shaft of your pen should rest just behind the middle joint of your forefinger.

PROJECT INSTRUCTIONS

This project is designed to check the control of your pen placement. Read all instructions carefully. Begin by using your *broad* nib to copy the strokes. Your paper should be flat upon a hard writing surface and slanted so that the bottom corner (the left corner, if you're right-handed) is pointed at you.

ADVICE TO LEFT-HANDERS

Since the nib of the Elegant Writer (and most other brands) is cut straight across it can be used by both left-handers and right-handers.

But if you're left-handed, you may have your own way of holding your pen.

If you write with your hand under the line, your paper is canted (slanted) with the upper left corner centered. Your elbow is close to your body and the end of your pen's barrel is aimed at your heart. You will push in the same direction as the right-hander. If you hook your hand above the line, your paper is apt not to be slanted. Your elbow is bent outward and your pen is angled toward the left. You'll *pull* your pen where the text indicates *push*.

■ The correct nib angle, top, keeps letters from looking too heavy, center, or too thin, bottom.

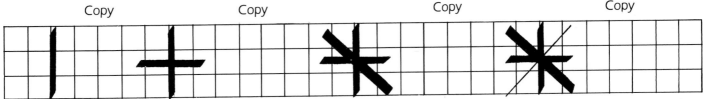

| Copy | Copy | Copy | Copy |

Draw a vertical line.

Repeat step one and draw a horizontal line.

Repeat steps one and two and add a diagonal from upper left to lower right.

Now pull all three steps together and complete with a diagonal from lower left to upper right.

CHECKLIST:

1. Are your vertical and horizontal lines equal in thickness?
2. Is your downward diagonal the thickest of strokes? It should be because you have used the full breadth of your pen.
3. Is your upward diagonal the thinnest of strokes? It should be because you have used the edge of your nib. If it looks thick check the placement of your pen shaft. It should be almost upright, placed immediately behind your middle finger joint. If it's resting backward in your hand you will actually be writing with the back of your nib. The thin stroke then becomes thickened.

4. Is the 45-degree angle apparent at these six points?

Do this four step exercise again and check your results.

Practice

Project Two

UPPER CASE LETTERS

ELEMENTS OF THE UPPER CASE LETTERS

The *elements* or letter parts that form the upper case Italic letters are quite unique in that they're adapted from some of the distinguished characteristics of the serifed Roman Capitals, such as straight thick and thin lines and broad curves.

Several elements may be contained in one pen *stroke*,

■ The Italic hand is based upon the characteristic thick and thin elements of the Roman Capitals.

which I define as a continuous pen movement. A second stroke occurs when the pen is lifted from the paper and then repositioned to complete the letter.

This presentation of elements will acquaint you with the terminology I've used to describe the upper case letters later in this project.

ROMAN CAPITALS

Horizontal is an element lettered flat upon a line.

Horizontal push, a familiar term of the lower case, is actually a push against the pen nib toward the left.

Horizontal pull is a pull of the pen from left to right.

Crossbar is a horizontal pull.

The crossbar is made more attractive when the nib angle is lessened. This is one of the few times you'll alter the 45-degree angle rule.

This is the crossbar with the nib at the 45-degree angle.

Sharp serif is a slight downward pull toward the left that completes a horizontal pull stroke. It's hardly noticeable but does lend a finished look to the stroke, like the Roman Capitals looked chiseled into marble.

Serifed bar

Project Two

Side serif can be lettered to join the horizontal in one movement, as shown above and right.

For more control, you can letter the horizontal first, then add the side serif.

You can apply the side serif after the letter is completed. Place your nib upon the horizontal at its thinnest point and glide it downward to about half the height or less.

The continuous side serif is one flowing movement that gives a counter balance to wide letters. The side serif pushes upward, glides into the horizontal, abruptly descends along the writing slant (stem), to about two nib widths above the baseline, broadly swings toward the left, and extends beyond the upper serif.

For more control you may prefer to write this element in three strokes. **1.** Letter the stem stroke. **2.** Pull a side serif downward. **3.** Swing the broad curve to the right to join at the fine point of the stem. This causes the element to appear as though it had been written in one continuous movement.

Foot is aptly named. It's the element on which some letters stand. The foot is the result of a stem stroke pushing toward the left at about two nib widths above the baseline, then retracing toward the right.

The narrow foot is equal on both sides of the stem.

The foot is pulled farther right to accommodate the width of different letters.

It attractively completes a serif when you pull the nib on an upward diagonal and quickly pick up the pen.

Bowl is the enclosure resulting from curved elements.

Leg is the lower diagonal element of the **R** and **K**. It stretches straight out to give these top-heavy letters support but never extends so far as to trip up the next letter.

Tail is also a straight diagonal element, but it extends further than the leg. It doesn't interfere with the letter that follows because it descends below the baseline.

PEN POINTERS

Remember that you can create a piece of calligraphic art by properly handling the pen. Here are some do's and don'ts:

1. *Hold your pen at the 45-degree angle.* This is the single most important factor in creating the beautiful thick and thin strokes of the Italic hand.
2. *Don't write with the corner of the nib.* This alters the thick and thin look of the Italic.
3. *Don't apply undue pressure.* This, too, will alter your nib size and may cause your point to become more flexible and harder to control. (It may also produce blots on certain parts of letters.)
4. *Replace the cap.* Marking pens dry up with exposure to air. You may want to keep several of the same size on hand, because they don't last forever. If your pen starts to dry out, the edges of your pen stroke will look ragged, and no amount of pressure will alleviate this condition. Sometimes this rougher edge actually lends an artistic look to the letters, but generally you'll want your pen to draw a solid stroke.

Project Two

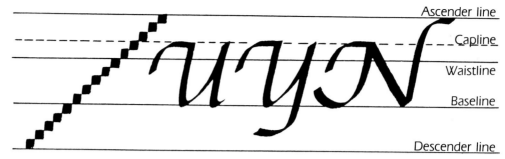

Ascender line
Capline
Waistline
Baseline
Descender line

HEIGHT OF UPPER CASE LETTERS

One unique characteristic of the upper case letter is its height. As you learned in Workbook 1, base letters (lower case letters or portions of letters that fit between the base and waistline) are five nib widths high; ascending or descending letters are ten nib widths high. The upper case letter is generally seven nib widths high, and has its own height line. The *capline,* shown in the illustration above, has been drawn throughout these projects to familiarize you with this height. It will, however, eventually become an imaginary line running along the top of your upper case letters.

UPPER CASE ALPHABET

The rest of this project is divided into two sections. The first section introduces you to the upper case letterforms. So that you can better see and feel the formation of each letter you'll first write with the *broad* nib pen. When you've completed the entire alphabet, in order that you can have as much practice as possible, you'll write the capitals again with the *medium*-nib pen.

The letters aren't introduced in alphabetical order nor even in the same sequence you learned the lower case letters in Workbook 1 since very few share common shapes with their lower case counterpart. Where possible, the upper case letters are grouped with those containing similar elements, but even then each letter is beautifully unique.

You'll learn upper case letters in the following order:

V W U Y
T F E L
D P R B
H K M N
O O Q
I J S
C C G
X Z A

As in Workbook 1, you'll be learning variations for some of these letters, so you can choose your preference.

PROJECT INSTRUCTIONS

Study and analyze each complete letterform. Read the instructions that introduce each letter and refer to them frequently as you practice. If the terminology is unclear, review the upper case elements on pages 4 and 5. Trace the shaded letters carefully, using your *broad-nib* marker and then copy them until the line is complete.

Remember you're not a machine. The beauty of the handwritten letter is that no two are exactly alike, but in spite of that you do want to

■ Here you can see how the ascending, descending, and base upper case letters result from different nib width heights.

write the best you can. Each letter is a new opportunity to improve the last. Use your time well and give each letter your full concentration.

The upper case letter comfortably blends with its lower case counterpart by sharing the same writing slant. Remember to maintain continuity by keeping all stem elements parallel to one another. To help you establish this writing slant, diagonal lines have been provided in this and several subsequent projects.

■ Too few or too many nib widths can cause your letters to look too squat or too tall. The N on the right is the appropriate size.

Project Two

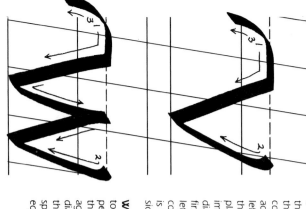

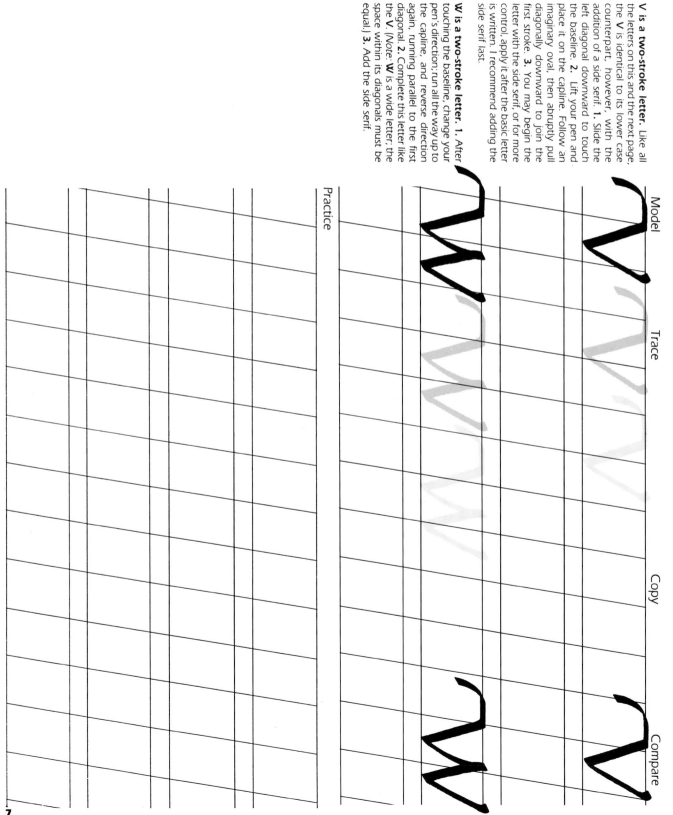

| | Model | Trace | Copy | Compare |

V is a two-stroke letter. Like all the letters on this and the next page, the V is identical to its lower case counterpart, however, with the addition of a side serif. **1.** Slide the left diagonal downward to touch the baseline. **2.** Lift your pen and place it on the capline. Follow an imaginary oval, then abruptly pull diagonally downward to join the first stroke. **3.** You may begin the letter with the side serif, or for more control, apply it after the basic letter is written. I recommend adding the side serif last.

W is a two-stroke letter. 1. After touching the baseline, change your pen's direction; run all the way up to the capline, and reverse direction again, running parallel to the first diagonal. **2.** Complete this letter like the V. (*Note:* **W** is a wide letter; the space within its diagonals must be equal.) **3.** Add the side serif.

Practice

7

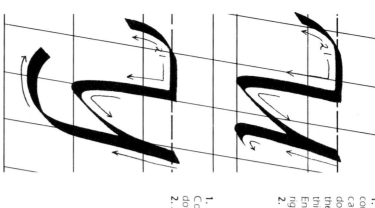

1. At the bottom of the first stem, continue to curve upward to the capline. Immediately pull a downward second stem, parallel to the first; retrace the upper half or thickened portion of the branching. End with a simple pull toward the right and a quick pick-up of the pen.
2. Add side serif.

1. Begin with the **U** letterform. Continue the second stem downward like the **J** letterform.
2. Apply side serif.

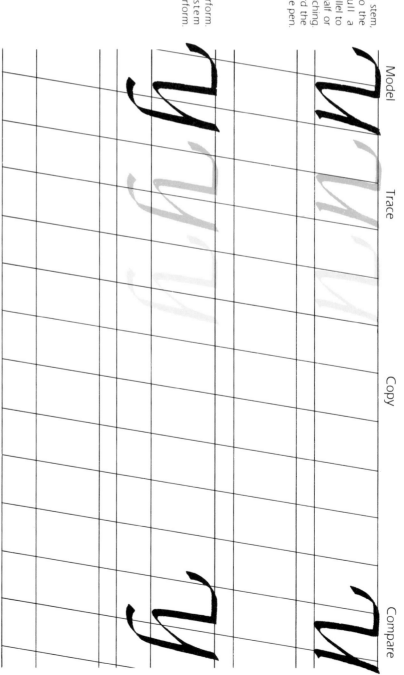

Model | Trace | Copy | Compare

Practice

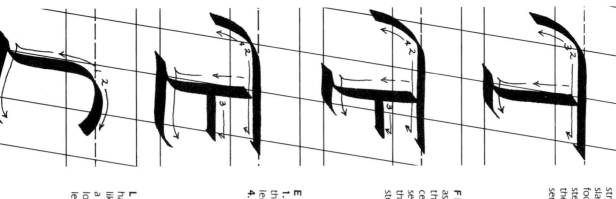

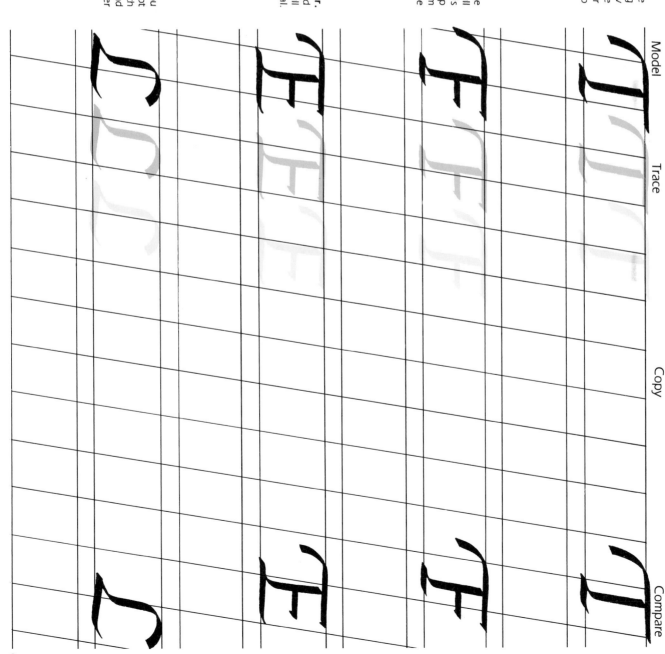

T is a two-stroke letter. 1. Pull the straight stem along the writing slant; retrace at the foot. The narrow foot is equal on both sides of the stem. **2.** Pull the horizontal to center the stem and end with the sharp serif. **3.** Apply side serif.

F is a three-stroke letter. 1. Write as the **T**, with stem and foot. **2.** Pull the horizontal so the stem is centered, complete with the sharp serif. **3.** Pull a serifed bar out from the right side, at midpoint on the stem. **4.** Apply side serif.

E is a three-stroke letter. 1.–3. Write it like the **F**, but extend the foot and serifed bar the full length of the upper horizontal. **4.** Apply side serif.

L is a two-stroke letter. 1. You have two choices: an extended foot like the **E**, or a tail. **2.** Complete with a wide curve which gives a broad look in keeping with the other letters.

Model Trace Copy Compare

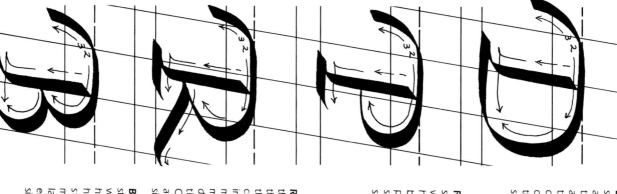

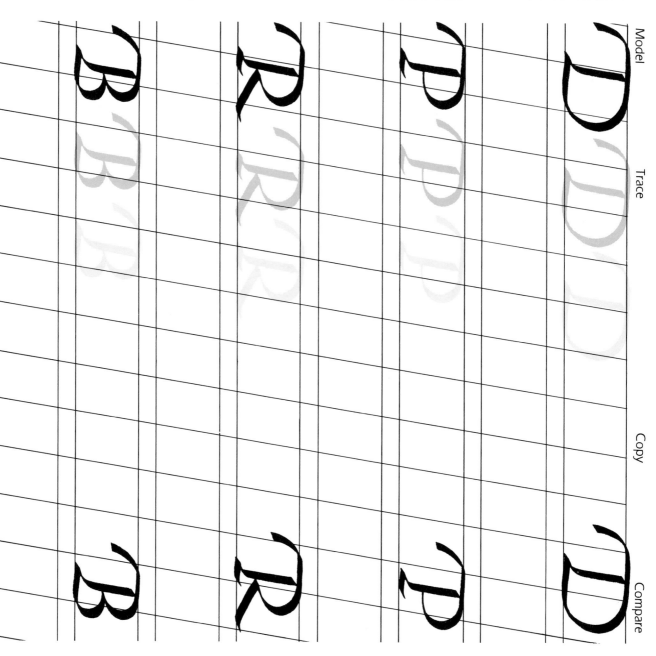

D is a two-stroke letter. 1. Pull the straight stem along the writing slant and retrace at the foot, extending it the same length as for **E**. Finish with a slight upward pull. **2.** Broadly pull the horizontal along the capline to center the stem; begin the wide curve downward to join with the thin point of the first stroke. **3.** Apply side serif.

P is a two-stroke letter. 1. Pull the straight stem downward and end with a narrow foot. **2.** Pull the horizontal to center the stem, then begin a broad downward curve that pushes inward to midpoint of the stem, forming a bowl. **3.** Apply side serif.

R is a two-stroke letter. 1. Create the same stem stroke and foot as for the **P**. **2.** Pull the second stroke to the right; begin the downward curve to form the bowl, pushing inward to touch the stem below midpoint. Continue the pen movement by pulling a straight diagonal out to the right, beyond the widest part of the bowl. Conclude with an upward pull and a quick lifting of the pen. **3.** Apply side serif.

B is a two-stroke letter. 1. Pull the straight stem downward and end with a foot that extends one and a half times the **P** foot. **2.** Glide the horizontal downward toward the stem, forming a bowl above midpoint. The lower bowl is slightly larger; complete by joining it to the end point of the first stroke. **3.** Apply side serif.

Model Trace Copy Compare

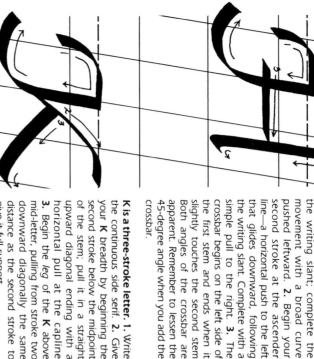

H is a three-stroke letter. 1. Pull your first stroke horizontally toward the right. Abruptly descend along the writing slant; complete the movement with a broad curve pushed leftward. **2.** Begin your second stroke at the ascender line—a horizontal push to the left that glides downward, following the writing slant. Complete with a simple pull to the right. **3.** The crossbar begins on the left side of the first stem and ends when it slightly touches the second stem. Both angles of the crossbar are apparent. Remember to lessen the 45-degree angle when you add the crossbar.

K is a three-stroke letter. 1. Write the continuous side serif. **2.** Give your K breadth by beginning the second stroke below the midpoint of the stem; pull it in a straight upward diagonal ending with a horizontal pull at the capline. **3.** Begin the leg of the K above mid-letter, pulling from stroke two, downward diagonally the same distance as the second stroke to give it full support.

Model Trace Copy Compare

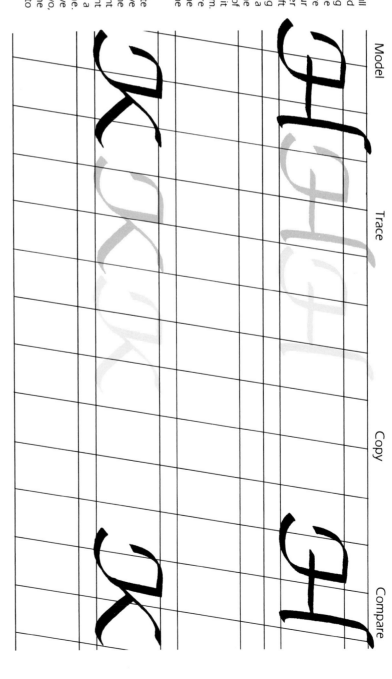

Practice

Project Two

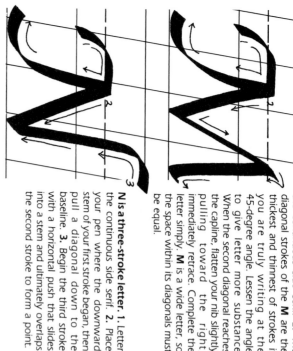

M is a two-stroke letter. 1. Write the continuous side serif. **2.** The diagonal strokes of the **M** are the thickest and thinnest of strokes if you are truly writing at the 45-degree angle. Lessen the angle to give letter more substance. When the second diagonal reaches the capline, flatten your nib slightly, pulling toward the right; immediately retrace. Complete the letter simply. **M** is a wide letter, so the space within its diagonals must be equal.

N is a three-stroke letter. 1. Letter the continuous side serif. **2.** Place your pen where the downward stem of your first stroke began, then pull a diagonal down to the baseline. **3.** Begin the third stroke with a horizontal push that slides into a stem and ultimately overlaps the second stroke to form a point.

Model Trace Copy Compare

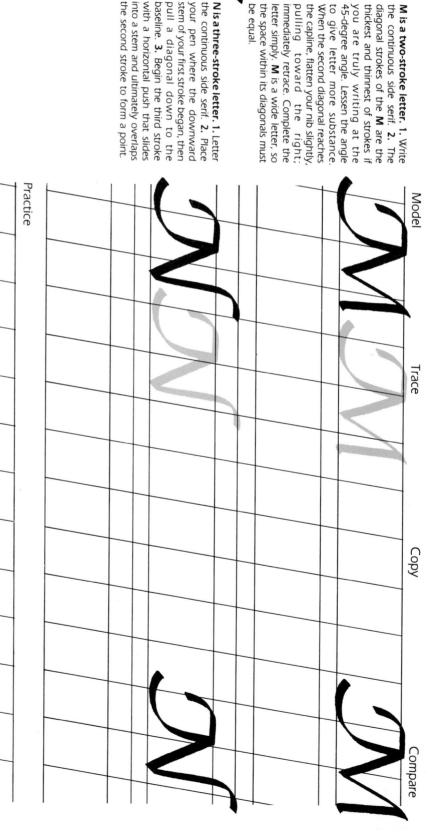

Practice

12

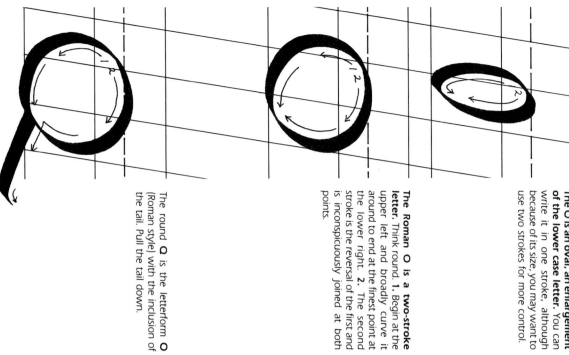

The O is an oval, an enlargement of the lower case letter. You can write it in one stroke, although because of its size, you may want to use two strokes for more control.

The Roman O is a two-stroke letter. Think round. **1.** Begin at the upper left and broadly curve it around to end at the finest point at the lower right. **2.** The second stroke is the reversal of the first and is inconspicuously joined at both points.

The round Q is the letterform O (Roman style) with the inclusion of the tail. Pull the tail down.

Model Trace Copy Compare

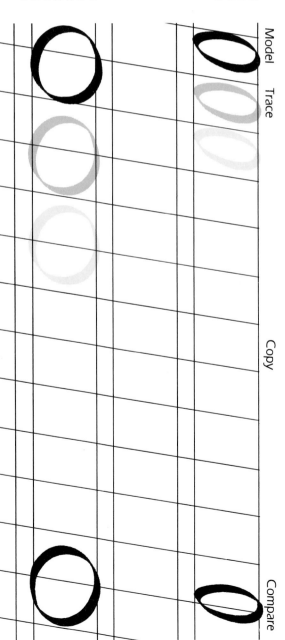

Project Two

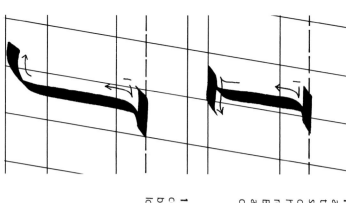

I is a one-stroke letter. The serifs are formed by the retrace strokes of the foot, which are equal on either side of the stem and equal to each other. **1.** For the upper serif, pull horizontally on capline to the right; retrace to the center of the letter. Bring the stem down along the slant and end with a retrace stroke, again centering the stem.

1. Begin the **J** like the capital **I**, but continue the stem below the baseline; complete the same as the lower case **j**.

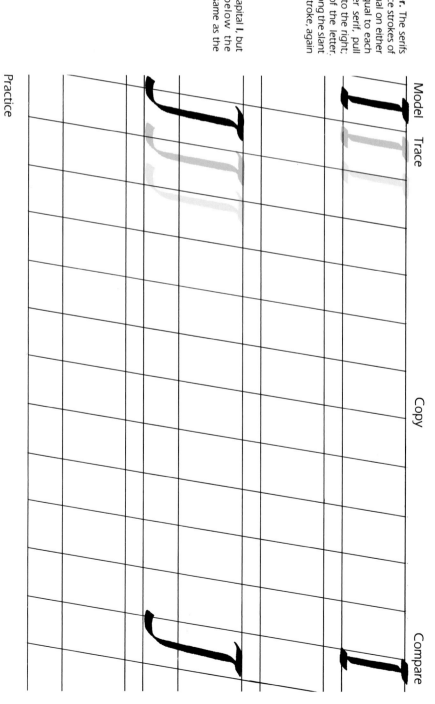

Model Trace Copy Compare

Practice

14

Project Two

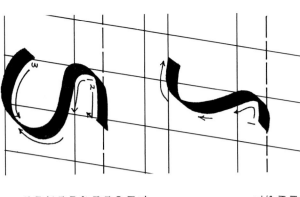

1. This **S** is an enlargement of the lower case **S**; two straight horizontals glide to or from a straight line that is slightly diagonal. This elongation requires control.

The Roman S is a three-stroke letter. 1. Visualize an oval resting on its side upon a circle. Starting at the thinnest point, the upper left, follow along the **S** curve and glide along to the thinnest point at lower right. **2.** At the upper curve apply the horizontal with a sharp serif. **3.** At lower curve, pull from left to right a broad circular curve to join the letter at its finest point.

Model Trace Copy Compare

Practice

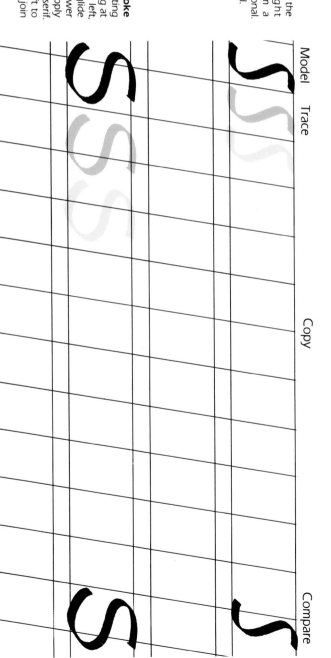

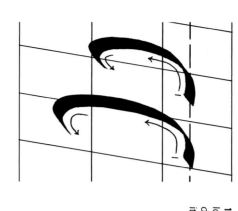

1. The elliptical **C** is an enlarged lower case **c**. This letter can also descend below the baseline, giving it an enhanced sense of importance.

Model Trace Copy Compare

Project Two

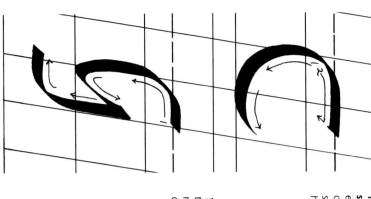

The Roman C is written in two strokes. It can also be used for emphasis, such as at the beginning of a paragraph. **1.** Write the first stroke of the Roman O. **2.** Apply the horizontal with the sharp serif.

1. To write the narrowed **G**, extend the elliptical **C** up to the letter's midpoint; descend like the lower case **J**.

Model	Trace	Copy	Compare

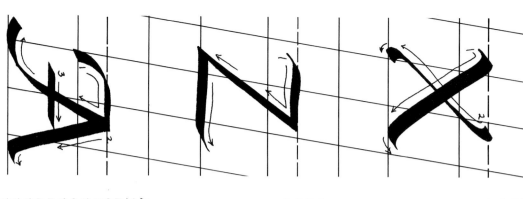

X is a two-stroke letter. 1. Write it the same as the lower case **x**, only wider. **2.** The second stroke crosses at the letter's midpoint.

1. The **Z** is like its lower case counterpart, only wider. Once again, to give this letter substance, turn your pen to thicken the diagonal.

A is a three-stroke letter. 1. When you write the continuous side serif, pull the left stem on a steeper diagonal than the writing slant. **2.** Place your pen on the top of the first diagonal and slide a second diagonal downward to the end with a simple right pull. **3.** Place the narrowed crossbar at the letter's midpoint, starting to the left of the first diagonal, pulling until it touches the second. The 45-degree angle of the crossbar is apparent.

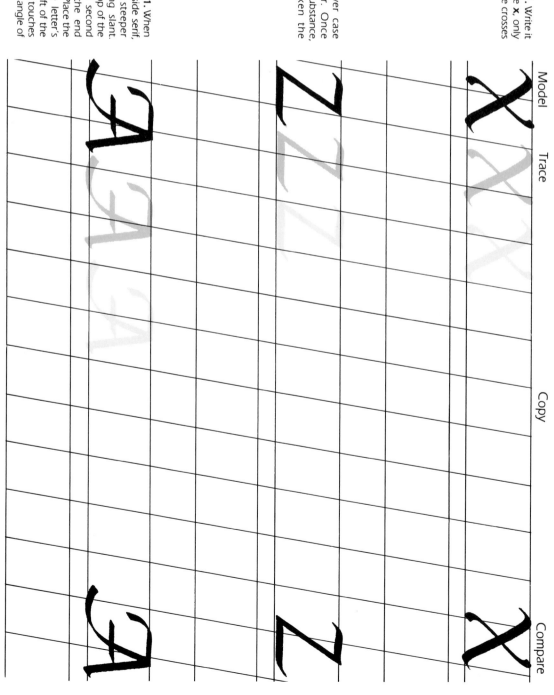

Model Trace Copy Compare

Practice Sheet: Broad Nib

Practice Sheet: Broad Nib

Project Two

You've completed your study of the upper case letterforms. Now it's time to practice them. Keep the Troubleshooting Chart (page 31) on hand as a reference.

Using your medium nib,

copy each letter. The letter at the *middle* of the line is there for you to compare with the last letter you wrote. If your letter deviates even slightly, refer to the Troubleshooting Chart. What is the problem? How can you correct it?

How can you correct it? After you've comfortably answered those questions, repeat the letter with a conscious effort to write it better than the one before. Although the line is limited, your practice must never be.

Model	Copy	Compare	Copy

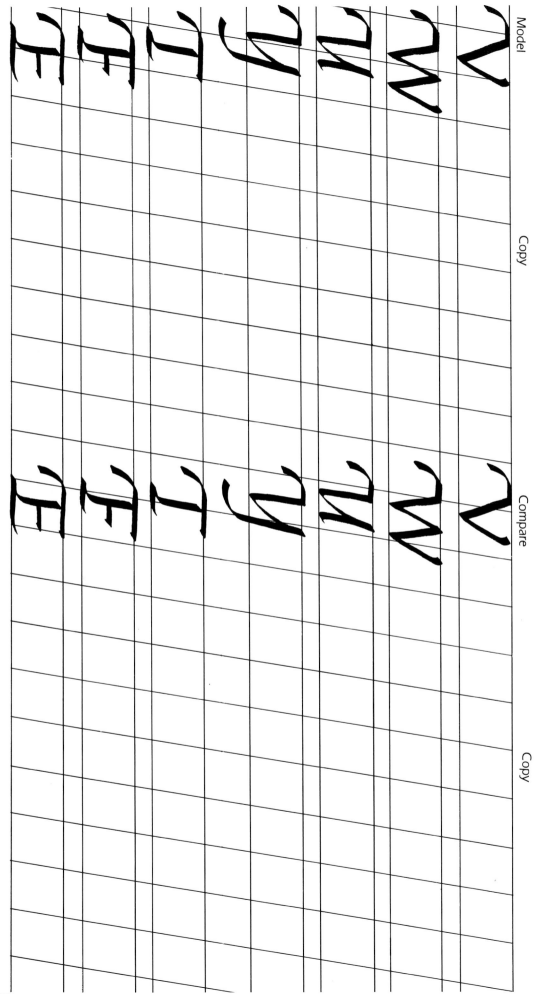

Model Copy Compare Copy

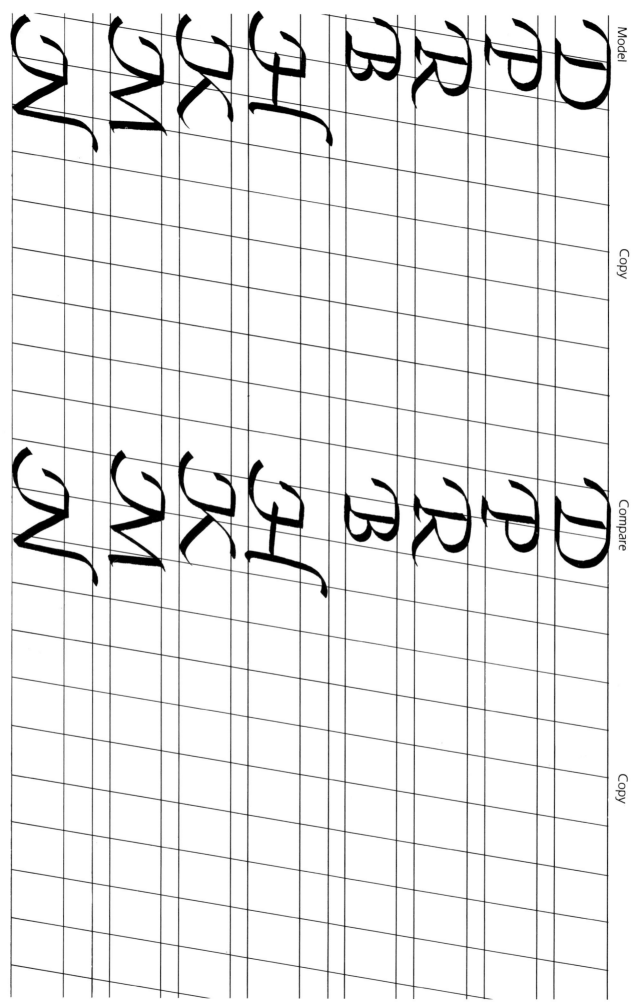

Model	Copy	Compare	Copy

o

oo

oo

r

u

u

r

u

g

s

s

o

oo

oo

r

u

u

g

s

s

25

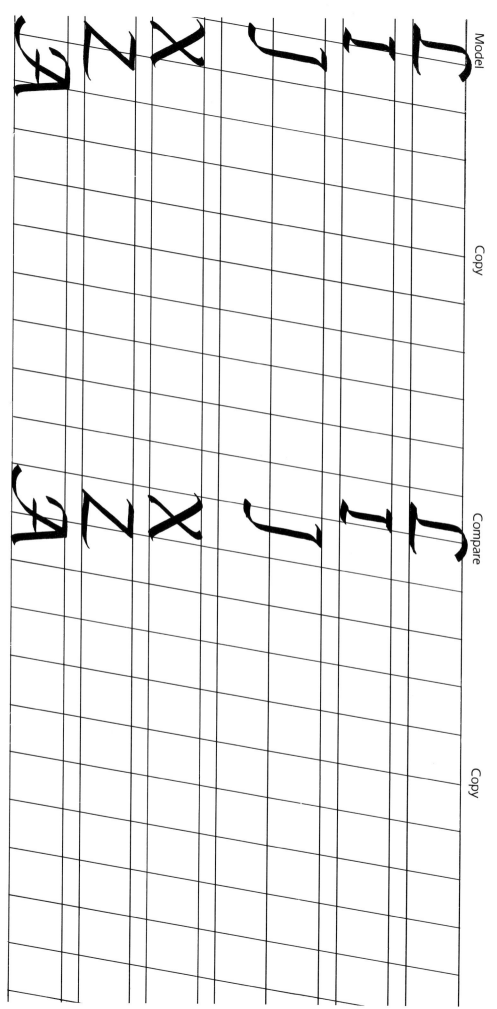

Model

Copy

Compare

Copy

Project Three

LETTER SPACING

This project initiates the writing of both upper and lower case letters. Each upper case letter, by its distinctive form, determines its own spacing, as you can see below. The lower case letter follows closely but doesn't touch it. To encourage you to use both cases, I recommend writing an abcedarian (a sentence in which each word follows in alphabetical order). Using each letter of the upper case alphabet, think of short words that you'll frequently capitalize, for example: **Avenue**, **Best**, **Church**, **Dear**, **End**, **From**, **Good**, **Happy**, **In**, **Joy**, **Kind**, **Love**, and so on. You can think of other words or proper names special to you. Using the *medium* nib, write them in alphabetical order to experience the relationship of each upper case letter next to a lower case letter.

Troubleshooting Chart

You mustn't overlook obvious flaws in your letters or you'll never improve your work; on the other hand, you mustn't be so severely critical that you discourage yourself. This Troubleshooting Chart illustrates common ailments many people experience in the early stages of learning calligraphy. If you see a familiar-looking letter or set of letters, refer to the model letter and practice that letter. Don't avoid writing letters that cause you trouble; instead, write them as much as possible. Always focus on the model and strive to improve upon your last effort.

Model	Horizontal Strokes Not Aligned	Incorrect Nib Angle	Too Curly (There is a style similar to this but it's not Italic.)	Too Wavy (Curls or waves distort the simple elegance of the upper case letterform.)	Too Narrow (Unlike lower case letters based on the oval, the upper case letters are basically round.)	Disjointed (Distortions are caused when elements aren't closely or correctly applied.)	Overlapped Angle (A letter can have a squared appearance because a stroke's 45-degree angle isn't visible.)
A	A	A A	A	A	A	A	A
B	B B	B B	B	B	B	B	B
C	C C	C C	C	C	C		
D	D D	D D	D	D	D	D	D
E	E E	E E	P	E	F	E	E
F	F F	F F	P	F	F	F	F
G	G G	G G	G	G	G		
H	H	H H	H	H	H	H	H
I	I I	I I	I	I		I	I
J	J J	J J	J	J		J	J

Troubleshooting Chart

Model	Horizontals Not Aligned	Incorrect Nib Angle	Too Curly	Too Wavy	Too Narrow	Disjointed	Overlapped Angle
K	K	KK	R	K	K	Kk	
L	Ll	LL	L	L	l	L	L
M	M	MM	M	M	M	M	
N	NN	NN	N	N	N	Nn	
O		OO		O	O	O	
P	Pp	PP	P	P	P	Pp	P
Q	q	QQ	Q	Q	l	Q	
R	RR	RR	R	R	R	R	R
S	SS	5 5	S	S	ʃ		
T	TT	TT	T	T	T	T	T
U	U	UU	U	U	u		
V	V	VV	V	V	v	Vv	
W	W	WW	W	W	w	Ww	
X	XX	X X	X	X	x	xx	
Y	Y	YY	Y	Y	y	Yy	
Z	2Z	Z Z	Z	Z	z	ZZ	

Project Four

NUMBERS AND PUNCTUATION

NUMBERS

You're learning numbers now because they're generally written to a height of seven nib widths, the same as the upper case Italic letters. The Italic numbers even have the same "personality" or look as their upper case counterparts. They're written on the same slant and are adaptable to either a round or oval shape.

The round-shaped numbers are seven nib widths high. All the numbers can be written to this height, but you can add some flair by elongating the ascenders (**6** and **8**) or descenders (**3**, **4**, **5**, **7**, and **9**). To do this, make them nine nib widths high and write them with one less stroke. You'll learn how to letter both round and oval-shaped numbers in this project.

In Project 5 you'll combine your skills in lettering numbers with lower and upper case letters, and punctuation. Experiment using the different number heights possible since you can really achieve unique effects. Do be careful that your combinations are visually balanced.

PUNCTUATION

Now that you're accustomed to writing at the 45-degree angle with a chisel-cut pen, you can understand why the period looks like a diamond and the comma and quotation marks are weighted the way they are. In this exercise you'll also write the colon, semi-colon, exclamation and question marks, all of which are shown here. After completing this project you'll be well equipped to write anything in Italic: names, dates, addresses, phone numbers and more.

First trace and copy with your *broad*-nib pen to learn the formation of the numbers and punctuation marks. In the second part use your *medium* nib for more practice.

Model Trace Copy Compare

Project Four: Broad Nib

Model Trace Copy Compare

3 3 3 3 3 3

4 4 4 4 4 4

5 5 5 5 5 5

6 6 6 6 6 6

7 7 7 7 7 7

8 8 8 8 8 8

9 9 9 9 9 9

:;!?"" () :;!?"" ()

Practice Sheet: Broad Nib

Practice Sheet: Broad Nib

Practice Sheet: Broad Nib

Model

Copy

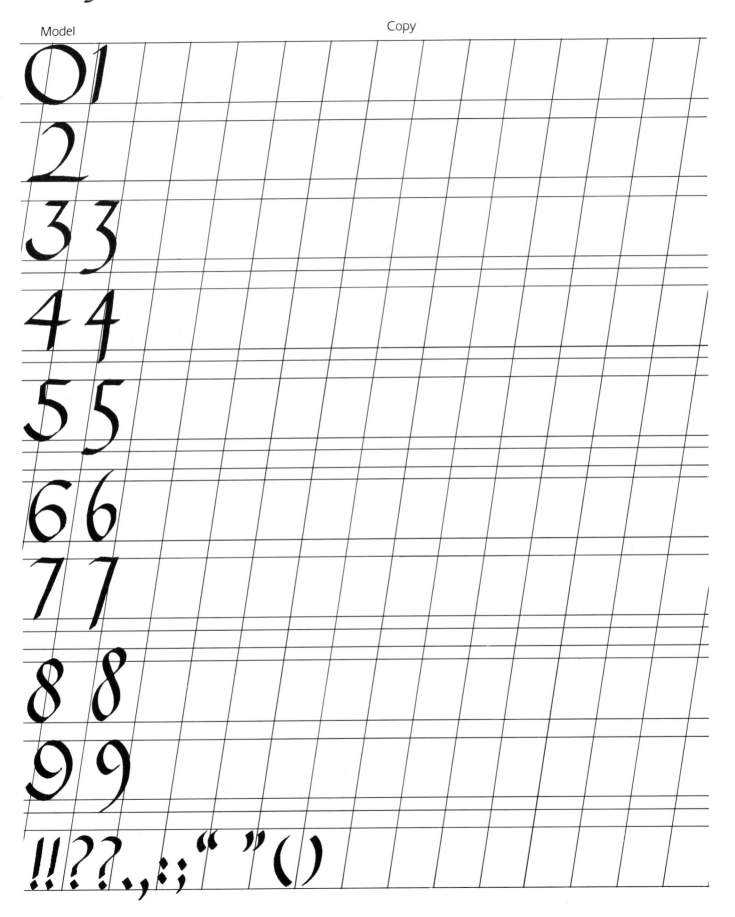

Practice Sheet: Medium Nib

Practice Sheet: Medium Nib

Project Five

WRITE ON . . .

Now that you are capable of writing anything in the Italic hand, your project is *to write*. Several practice pages are provided for this purpose—the baseline is indicated by the x; and the capline is a dashed line. The following are suggested combinations of the upper and lower case letters, numbers, and punctuation: today's date, your name, full address (street, city, state, zip code), birthdate, names of friends and family members, birthdays you want to remember, and your favorite quotation. Letter with your *medium*-nib pen; sit with proper posture, relax, and enjoy writing.

Practice Sheet: Medium Nib

Practice Sheet: Medium Nib

Project Six

CAPITAL IMPROVEMENT

MONOGRAMS

Your study has been so intense that now it's time to play! Monograms, combinations of upper case letters, are fun to put together to create interesting results. Space is provided on the following pages for you to work out many possibilities, using your initials and the initials of people special to you. Experiment with different combinations; you'll discover that some letters work together better than others.

When you've achieved a visually pleasing design, you can letter your final art onto sheets of stationery. Personalize your own stationery by writing your monogram on the top center of the paper or prepare a set as a gift.

PATTERNS TO ENHANCE YOUR MONOGRAMS

You can use any letter or letter element repetitiously to create an attractive pattern as shown above. One of the most simple is the diamond-shaped dot. It's a challenge to draw each equal in size and spacing; once you have the feel for it you've got yourself a mark of distinction. Use the edge (not corner) of your nib to form a fine line. Letter the center line of diamonds first, then count off and write the diamonds above and below center.

■ To give your monogram a mark of distinction, add a

.simple design on either side of the monogram.

■ Write two or three initials of a name. Be mindful of the

spacing that upper case letters require.

■ Enlarge the center letter by using the *broad nib*. Usually the first letter of the last name is the one that is cen-

tered and enlarged. Use the *medium nib* for the first and middle initials on either side.

PEN NIB WIDTHS

The grid lines for the projects in this workbook were drawn to fit your *broad* and *medium* nibs. Now, though, you may want to establish your own guidelines. (Or you may prefer to "freehand" the following exercise.) The distance between two guidelines is in direct relationship to the nib width of the pen you're using. To determine this distance turn your pen to the vertical 90-degree angle and pull the full breadth of the nib, forming a square. Stack these squares diagonally, touching corners, as you saw in Project 2.

Make the lower case base letters five nib widths high, the ascenders or descenders ten nib widths, and the f, the only letter that both ascends and descends, at least thirteen nib widths. Your upper case letters, remember, are generally seven nib widths high.

Although this is your final project in Workbook 2, calligraphy is only beginning for you. You've learned the ba-

sics of a very exciting skill; move on to Workbooks 3 and 4 to expand the possibilities of the Italic hand for you. Go back to Workbook 1 now and write your name and today's date on the Visual Progress Record, using the upper case letters and numbers you've just learned. See! You *have* made progress! Enjoy your letters. The best is yet to be.

■ Overlay letters by stepping them or by placing a smaller letter within a larger one.

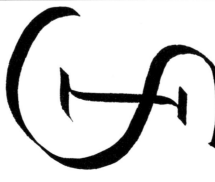

Practice Sheet

Practice Sheet